Portraits

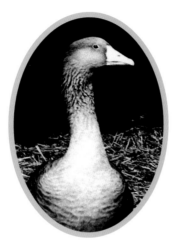

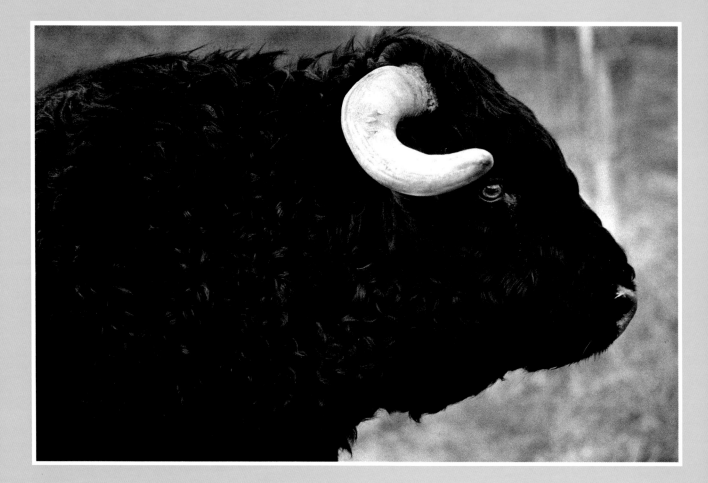

Bull Pawlet, Vermont 1994

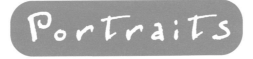

Portraits

PHOTOGRAPHS OF
FARM ANIMALS BY

Danielle Weil

INTRODUCTION BY

Verlyn Klinkenborg

ARTISAN · NEW YORK

Photographs copyright © 1995 Danielle Weil
Introduction copyright © 1995 Verlyn
Klinkenborg

Production director: Hope Koturo

Published in 1995 by Artisan, A Division
of Workman Publishing Company, Inc.
708 Broadway, New York, NY 10003

Printed in Italy
10 9 8 7 6 5 4 3 2 1
First Printing

Library of Congress Cataloging-in-Publication Data
Weil, Danielle.
Portraits / photographs of farm animals by Danielle Weil;
introduction by Verlyn Klinkenborg.
ISBN 1-885183-32-1
1. Domestic animals—Pictorial works.
2. Domestic animals—United States—Pictorial works.
I. Klinkenborg, Verlyn. II. Title.
SF76.W45 1995
779'.9636—dc20 95-22814

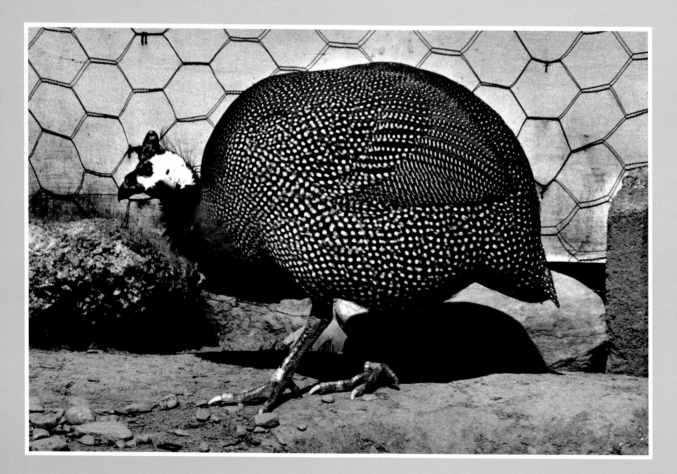

Guinea Hen *Walton, New York* *1993*

Portraits

WHEN I WAS A BOY — so these stories always begin — I spent a summer or two on my eldest uncle's farm in northwestern Iowa. It was the farm where my father was raised, and when I say I spent a summer or two there I mean it's summer in all my memories of the place. The sun is hot on the cracked sidewalk leading down from the back door to the garden gate. The lilacs are long over. The grove is in full, ominous leaf.

But in photographs from my father's childhood it is often winter on the farm, and you can see in those photographs that the farmsteads in the distance have been joined, not separated, by the snow lying out on the fields. In the mudroom between the kitchen and the back door of the farmhouse, there were signs of winter even in the summers when I came to visit — enormous quilted coveralls, oil-stained at the cuffs, hung by the nape on hooks, like headless convicts all in a row. I knew that in winter the mud in the machine yard froze into unbelievable shapes, and I imagined, though I never saw it, that in the animal yards a fog sometimes lay dormant just above the backs of the cattle and that in the low houses where the chickens and pigs were kept the body heat was often oppressive, too liquid, too penetrating to tolerate for long.

On that farm were dairy cows, beef cattle, hogs, and both the laying and the cooking kinds of chickens. In my father's day there had been draft horses and sheep and geese and a goat or two as well. In other words, there had lived on that farm, at one time or another, bulls, steers, heifers, cows, calves, boars, sows, shoats, gilts, colts, fillies, geldings, mares, stallions, roosters, cockerels, hens, pullets, ganders, geese, goslings, rams, ewes, kids, and lambs. To each of these a breed name was also assigned, and each came in a color that could be named specifically, too.

Some of these creatures also had personal names or an impromptu moniker that singled out a uniqueness, like a twisted horn or a hostile temperament. Of all these distinctions I was unaware. To me, even the difference between beef cattle and dairy cows was confusing at first.

But what was not confusing was the appeal of these animals, their power over my imagination. Even now, remembering those days more than thirty years ago, I feel as though I'm looking past the horizon of my own life and into a painting by Constable. In the afternoons the dairy herd really did walk up an elm-shaded lane to a small, heavily trodden yard where they stood, like patient petitioners from Dostoevsky, meticulously aware of rank, waiting to be admitted to the milking parlor. The door would be slid back on its rollers, and one Holstein—always the same one—would make her way up the concrete ramp, swinging her rectangular head side to side as she came through the doorway, and then stepping along the barn to her stanchion with all the gravity of a town woman carrying a hot dish to a church supper. The air would soon be filled with barn swallows and the rhythmic, wheezing sound of automatic milkers.

Almost every day I found myself in a corner of the farmyard where the hog fence met the side of a granary. There, I could stand on one of the fence rails, being careful not to let my feet poke through to the other side, and I could look in on the life of pigs. Unlike the humid climate in the farrowing house next door, the atmosphere above the hogpen seemed to be filled with a molecular dust that held the light. There were bogs of mud in the low spots, as there are in every good hogpen. Yet this was an overwhelmingly dry place, the locus of an effete, hairsplitting rationalism espoused by thin-skinned philosophers who were also profound students of their own bodily comfort. The hogs lolled, they fretted, they batted their small eyes in the noontime light, they tried to convey their intelligence to one another, and to me, but failed.

All the wood in the pen as high as a pig's back was sanded smooth by their rubbing, which I did not understand until the first time I stroked a mature boar's pompadour and realized that

it was bristle. Cleanliness was, of course, a fetish among the humans in the milk room, where milk was filtered and cooled in a stainless steel tank, but it was no less a fetish among the hogs in the hogpen, though you had to look for it. Perhaps the cleanest spot on the whole farm—with apologies to my aunt Esther—was the hog trough between meals. Its inner surface had been worn as smooth as ivory, as smooth as the trencher of an ascetic desert saint.

But it wasn't only the animals I noticed. It was also the humans among the animals. I was struck by my uncle Everon's fearlessness as he moved among the hogs, a fearlessness all the more remarkable because the hogpen had been represented to me as a terribly dangerous place. If a cow leaned too heavily on one of my cousins as he washed her bag before milking, he would simply thump her on her bony flank until she stood over.

I, who had grown up almost solely among people, expected to see human responses from these animals—resentment, outrage, peevishness. I didn't realize that the high disdain with which the cattle treated my cousins was a form of comedy or that the squealing of the hogs as my uncle moved among them was absurd self-dramatization. Do you suppose it was anyone's purpose, let alone the collective purpose of so many human generations, to breed so much dignity into farm animals? Who needed the intellect of the pig—its radical smartness? Who would set out to engender an eye as calm and unjudging, yet so capable of reflecting human self-judgment, as the eye you see in the head of a cow? Yet there they are, reminders of how utterly interwoven our fates have turned out to be. Farm animals are the product of co-evolution with humans, or rather we are the product of co-evolution with them. They are twinned with us. The word that applies to our link with them is neither *bond* nor *contract*: it is *covenant*.

This book is a collection of farm animal portraits by Danielle Weil. Her extraordinary photographs offer an opportunity that farm animals themselves rarely do when you approach them: you can look them in the eye and see what looks back at you. These are intimate por-

traits, and they capture their subjects in every state of undress, as it were. Some of the animals that appear here cannot help the gravity of their demeanor, while among others there is what you might call an hilarity of form.

It's easy to look at these photographs and see the strangeness of domesticated animals. What you'll need to look more deeply for is the nature of their familiarity.

We often talk about the capacity of photographs to reveal the strangeness of our world. But these photographs show us something harder to portray. They illuminate the mythic content of what has always been familiar to us, whether we've been aware of it or not. These photographs teach us something new about a subject from which newness is the last thing we expect.

It's true that you can't smell the barnyard in these photographs or hear the indiscriminate herd noises that rise from a pen full of cattle. For most readers, this book will measure the distance between their own lives and an agricultural existence that's increasingly remote from most Americans' experience. In my own life, I've been lucky, time and time again, to be called out to the country, to watch animals like the ones in these portraits shape the lives of humans lucky enough to come into daily contact with them. I think of these photographs as pictures of long-forgotten ancestors whose way of life is no longer quite comprehensible to us. Though you don't know much about how they lived, you can still see the family resemblance. You can almost hear the stories they would tell if we only knew how to hear them.

— *Verlyn Klinkenborg*

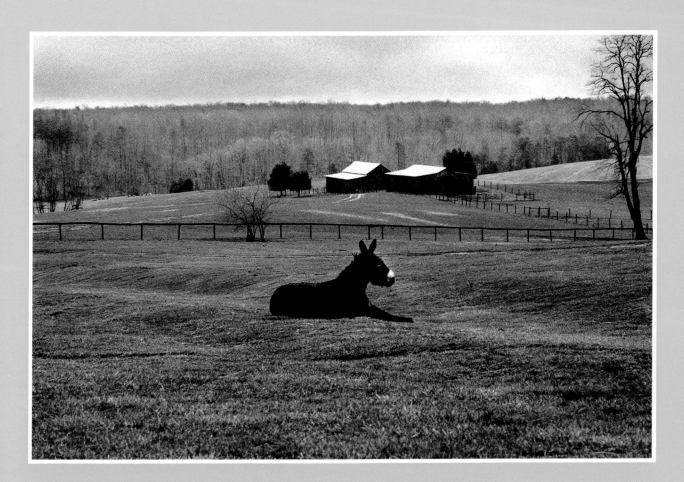

Donkey *Keene, Virginia 1993*

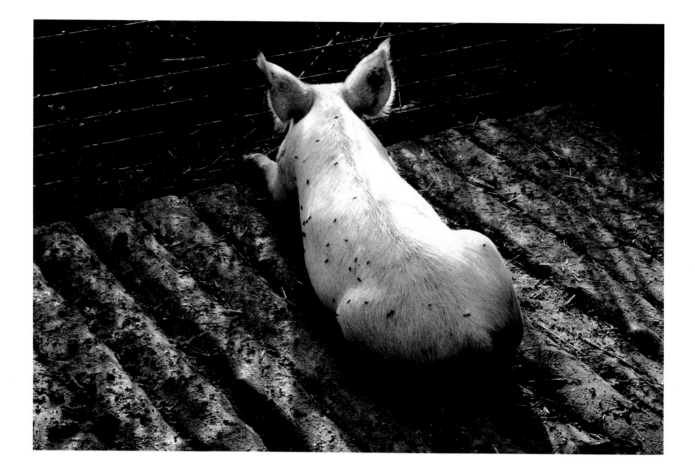

Pig *Concord, Massachusetts 1992*

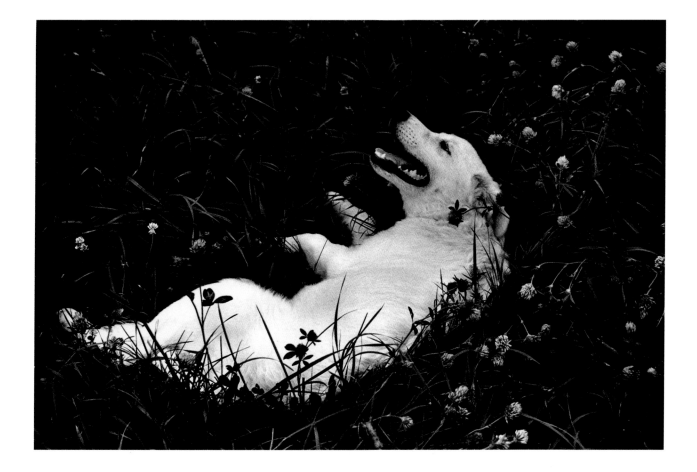

Maremma Guard Dog *Westminster West, Vermont 1993*

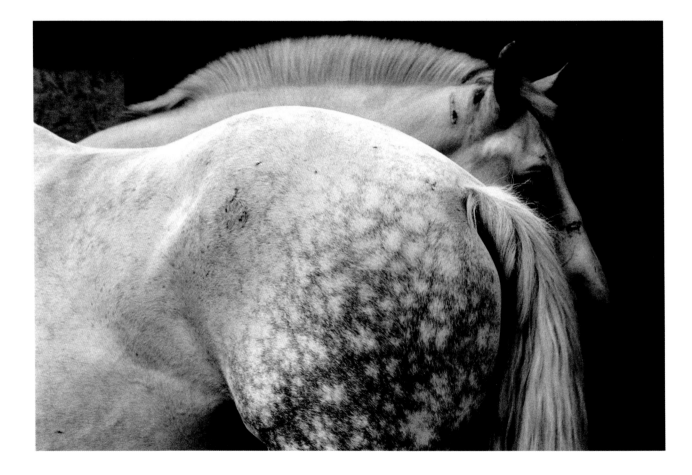

Percheron Horses *Wallingford, Vermont 1994*

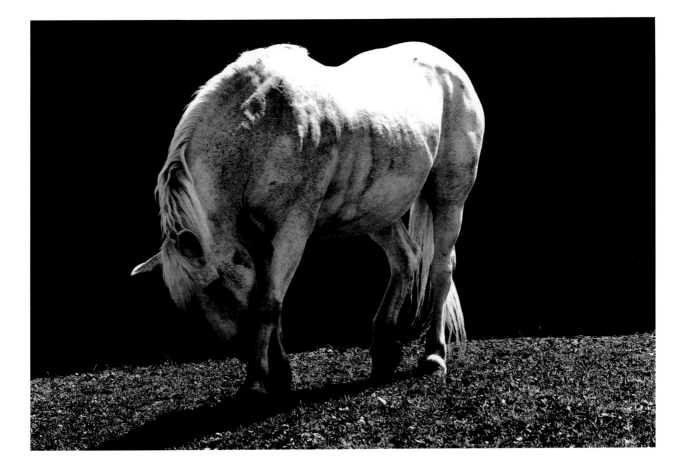

Morgan Cross Mare *Cooperstown, New York 1994*

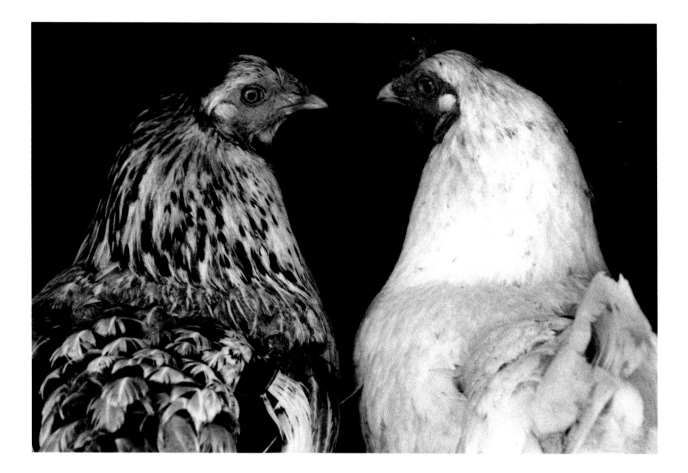

Hens *Walton, New York* *1993*

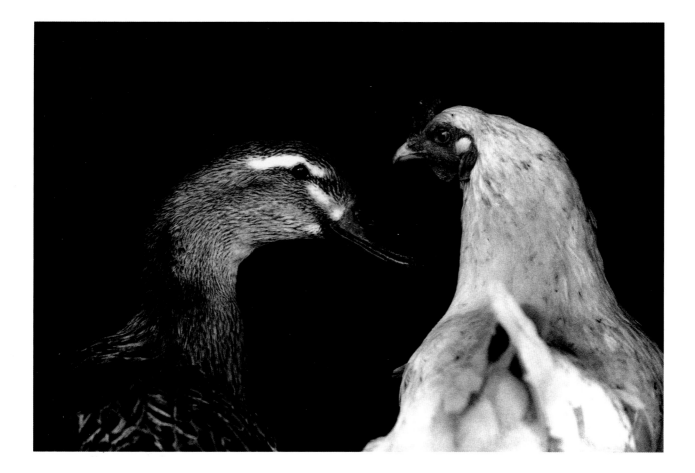

Rouen Duck and Hen *Walton, New York* *1993*

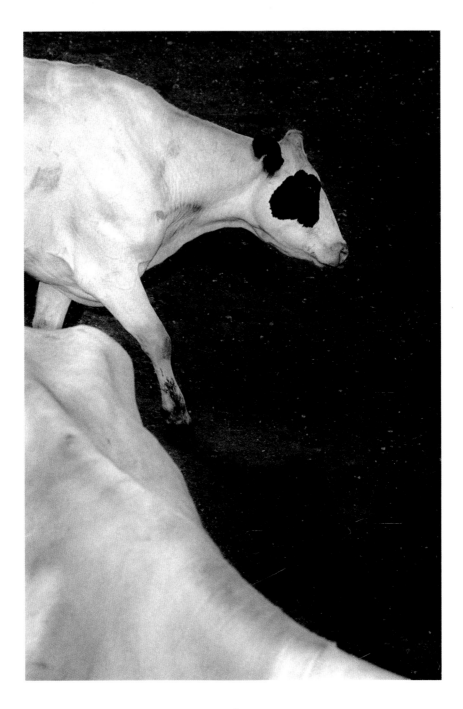

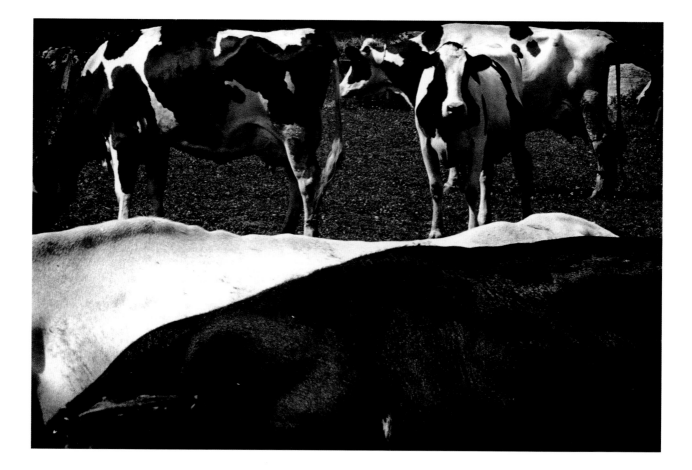

Holstein Cows *New London, New Hampshire 1983*

OPPOSITE Holstein Cows *Bridgehampton, New York 1983*

17

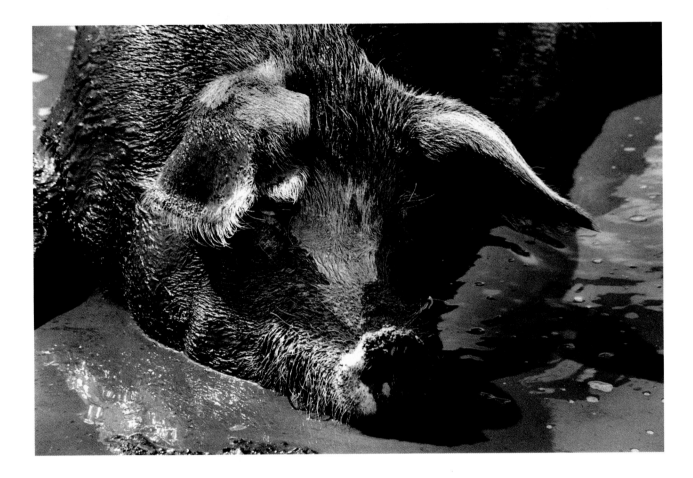

Pig *Red Hook, New York 1993*

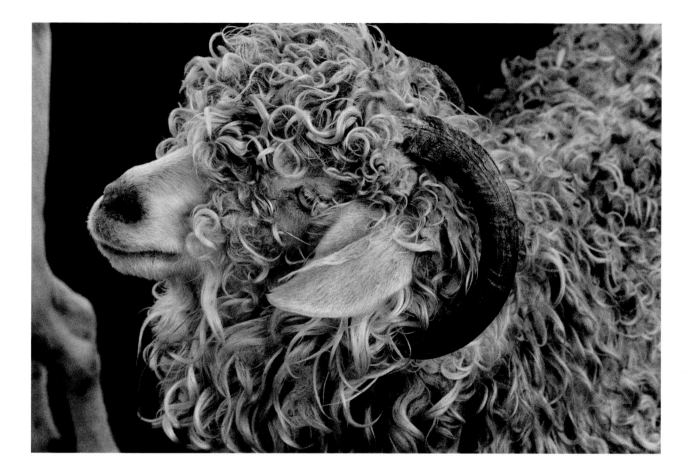

Angora Goat *Manchester, Vermont* *1994*

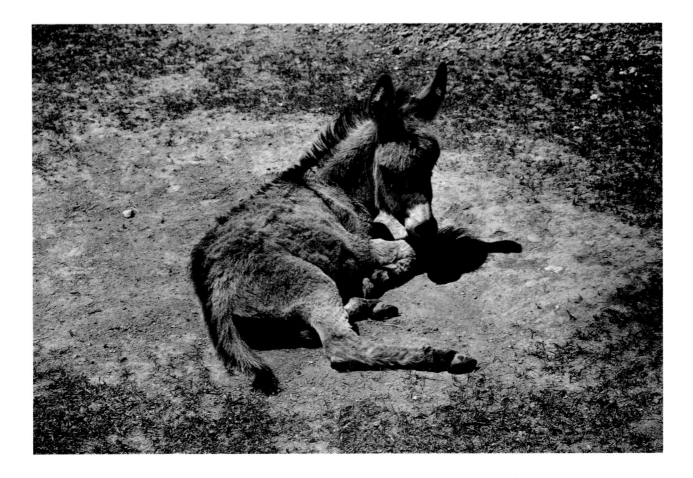

Miniature Donkey *Jordanville, New York* *1993*

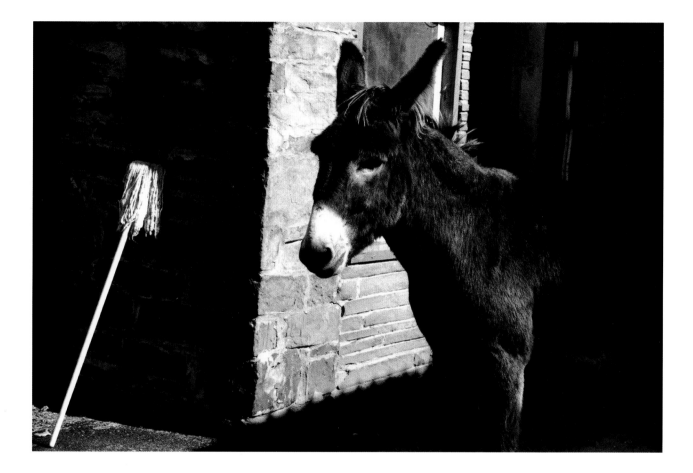

Donkey *Schyler Lake, New York* *1992*

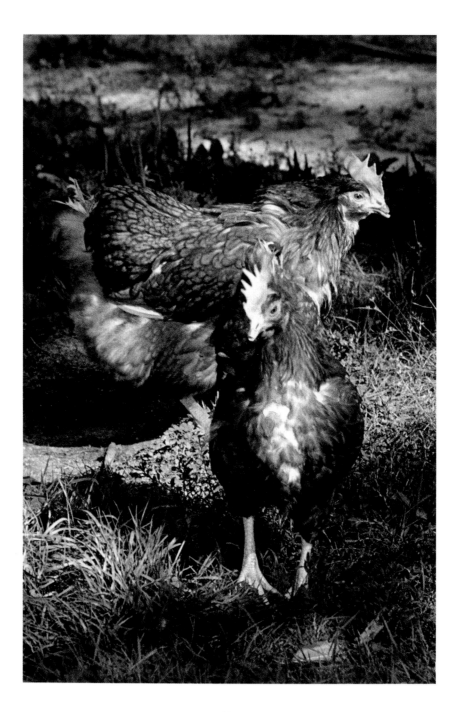

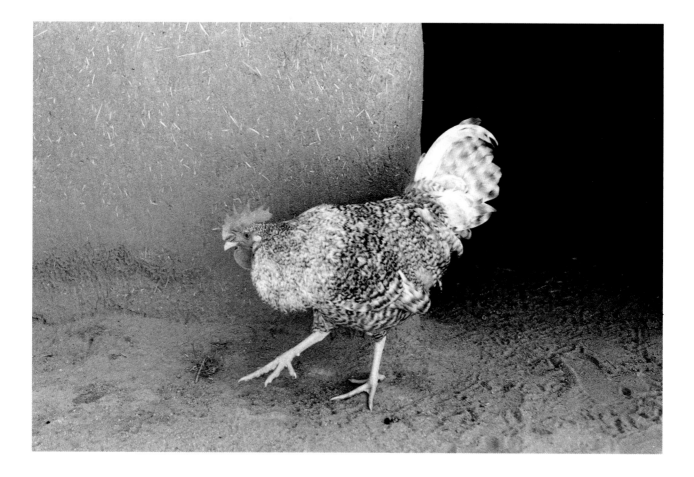

Bantam Chicken *Santa Fe, New Mexico 1994*

OPPOSITE Chickens *New London, New Hampshire 1983*

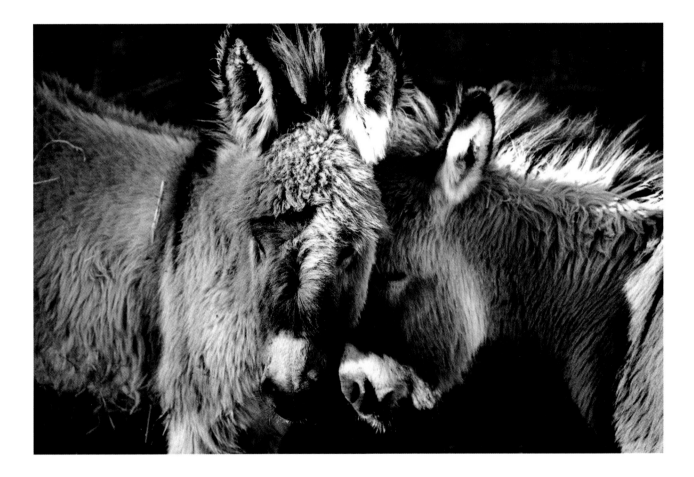

Miniature Donkeys *Charlottesville, Virginia 1993*

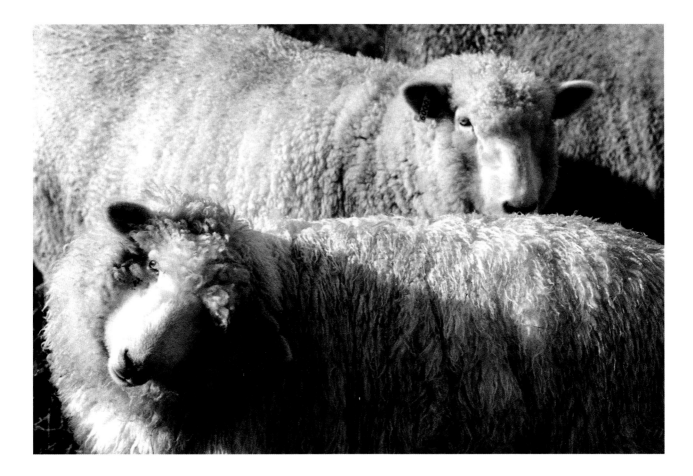

Romney Sheep *Manchester, Vermont* *1994*

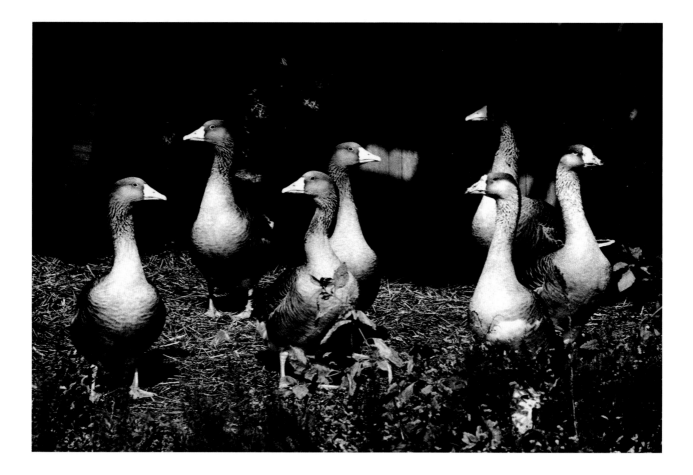

Canada Geese *Sagaponack, New York 1992*

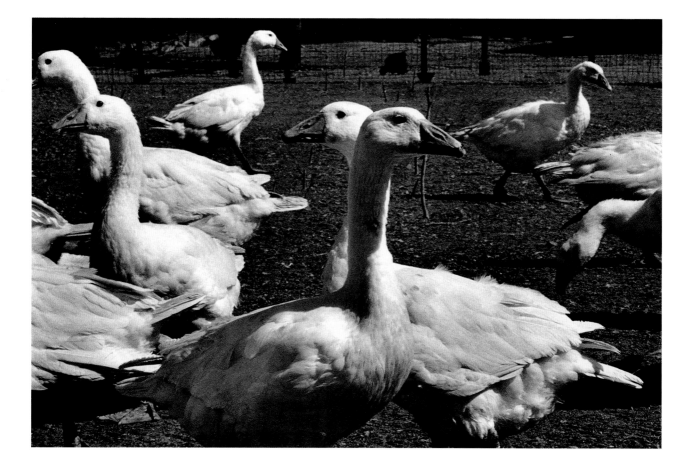

White Embden Geese *Easthampton, New York* *1983*

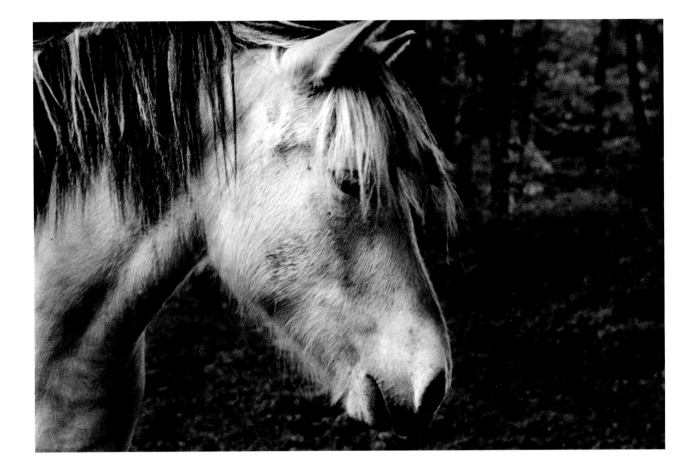

Norwegian Fjord Horse *Westminster West, Vermont* *1994*

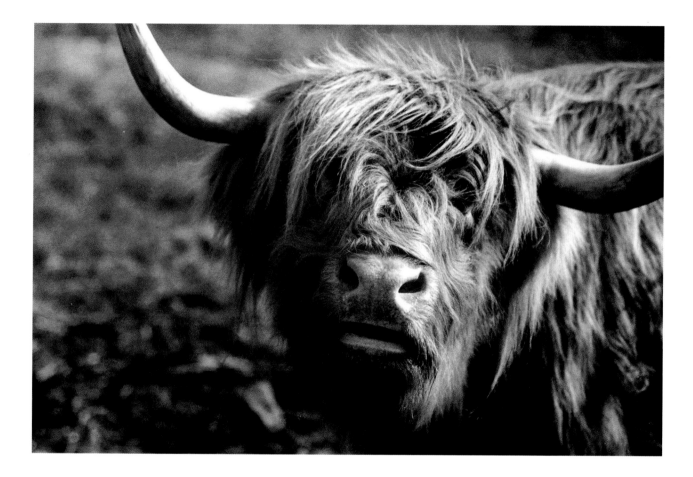

Scotch Highland Cow *Pawlet, Vermont 1994*

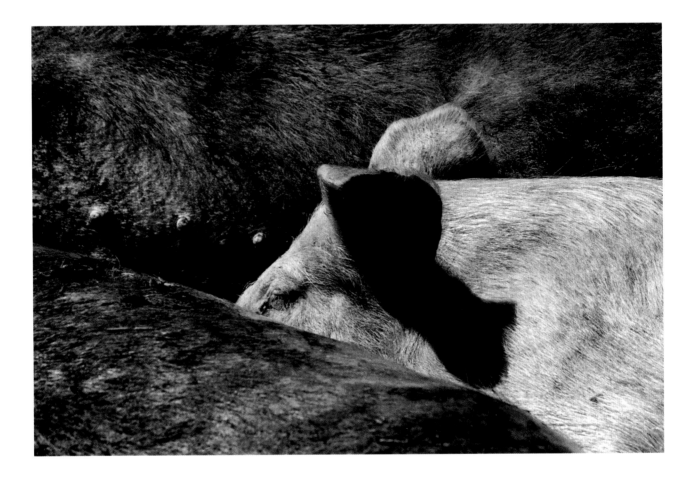

Yorkshire Cross Pigs *Burlington Flats, New York 1994*

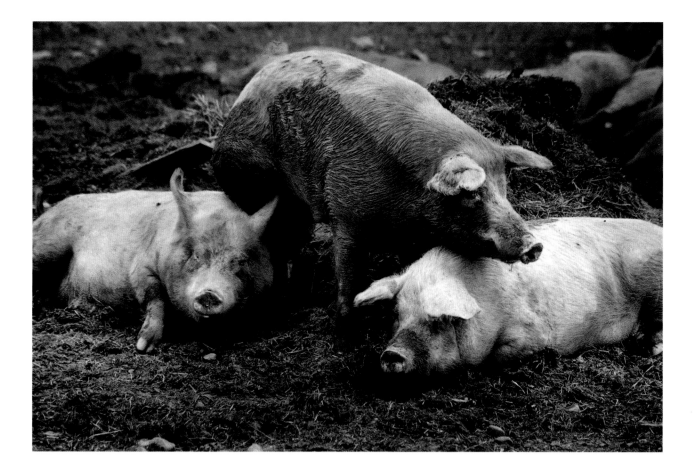

Yorkshire Cross Pigs *Burlington Flats, New York 1994*

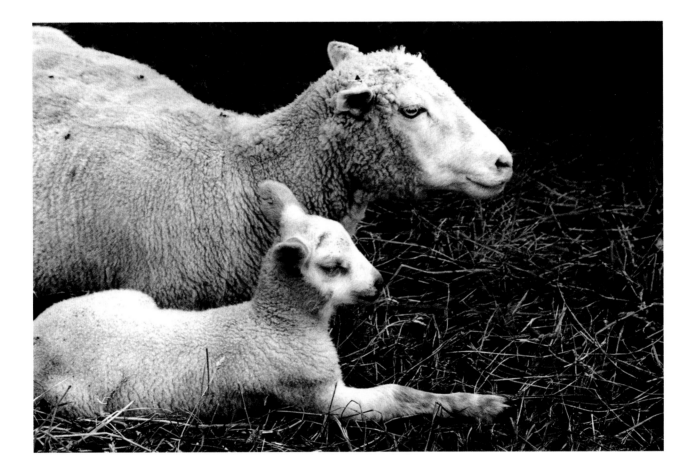

Dorset Cross Ewe with Lamb *Westminster West, Vermont* *1994*

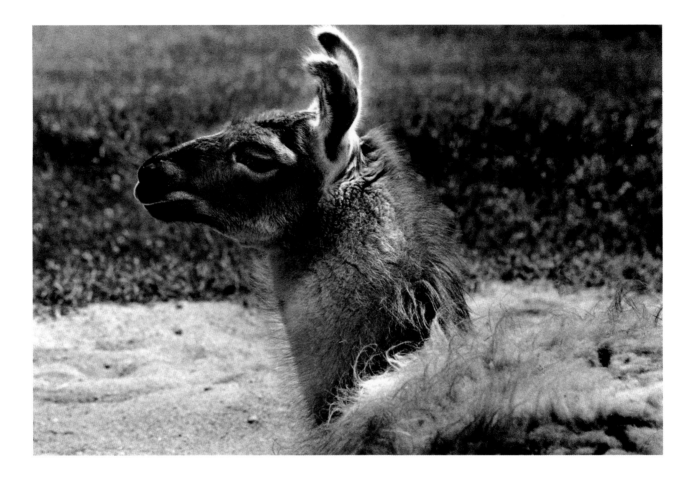

Llama *Putney, Vermont 1993*

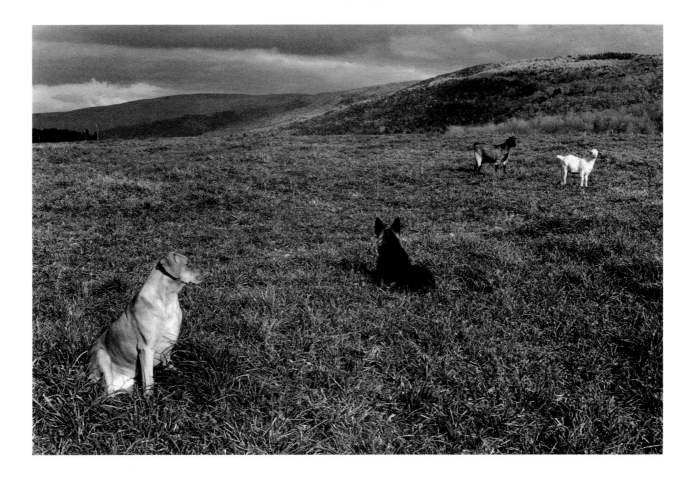

Farm Dogs and Goats *Manchester, Vermont 1994*

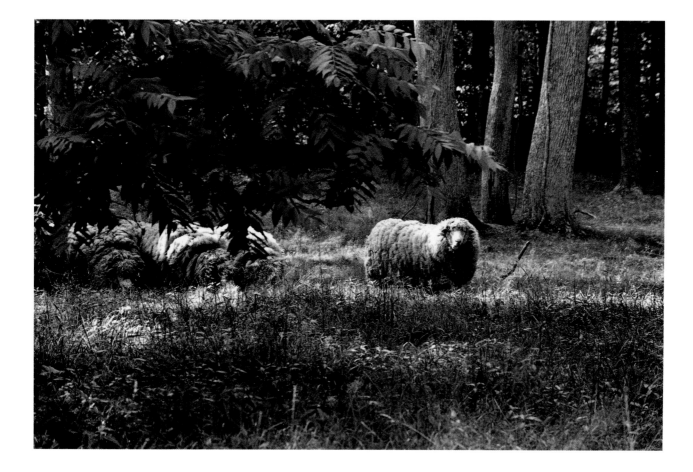

Sheep *Rhinebeck, New York 1992*

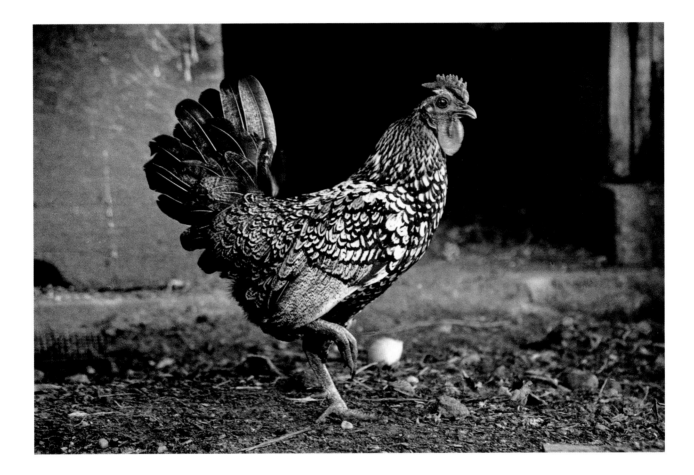

Araucana Bantam Hen *Bridgehampton, New York 1994*

OPPOSITE Rhode Island Red Rooster *Burlington Flats, New York 1994*

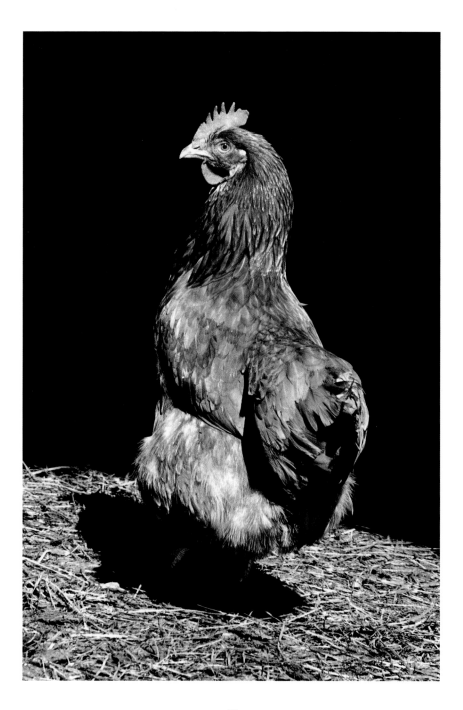

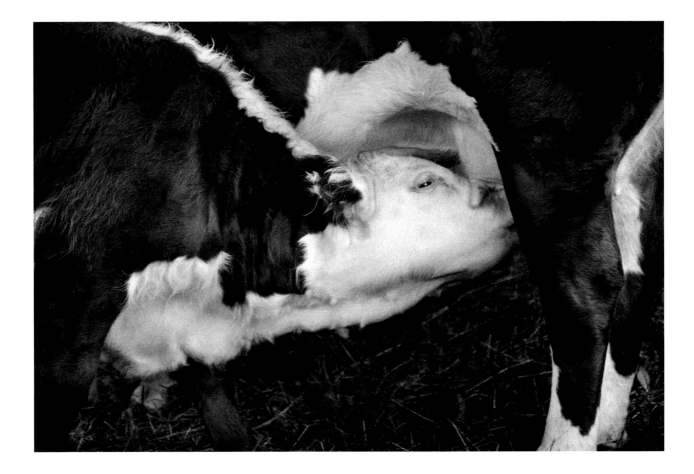

Polled Hereford Calf *Manchester, Vermont 1994*

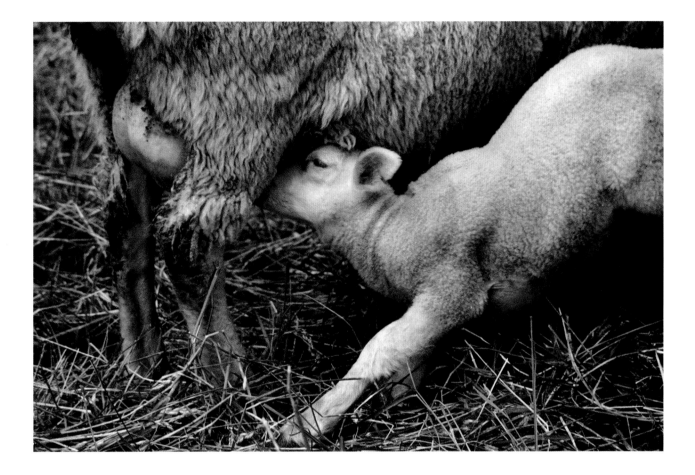

Dorset Cross Lamb *Westminster West, Vermont 1994*

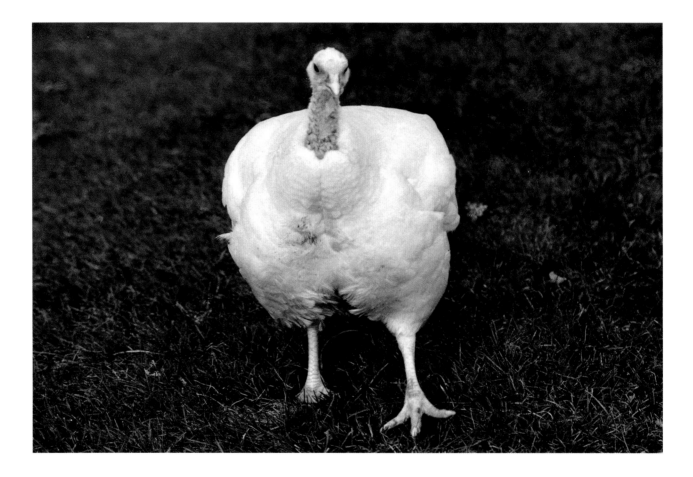

White Turkey *Manchester, Vermont* *1994*

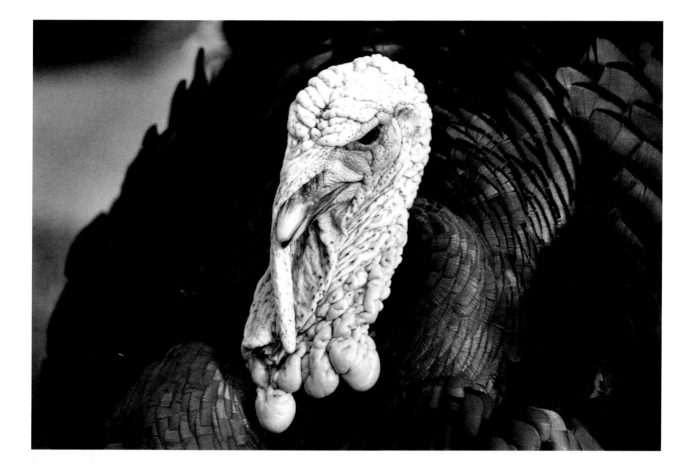

Bronze Turkey *Manchester, Vermont 1994*

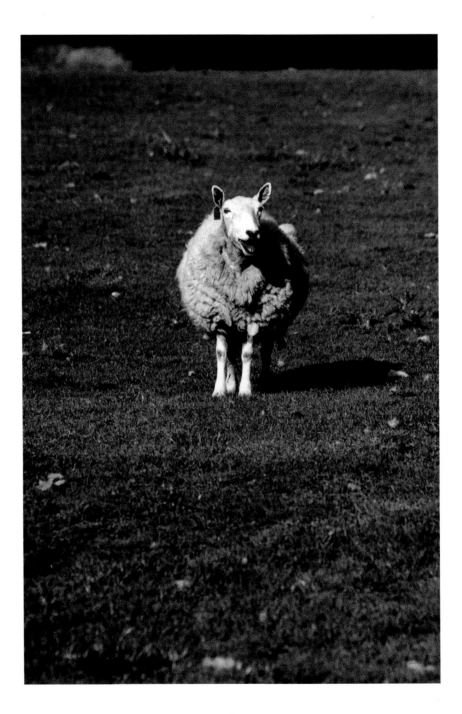

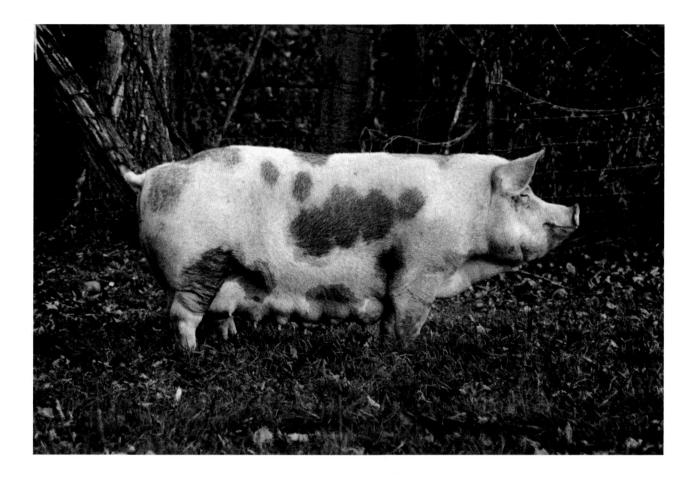

Sow *Manchester, Vermont 1994*

OPPOSITE Sheep *Walton, New York 1993*

43

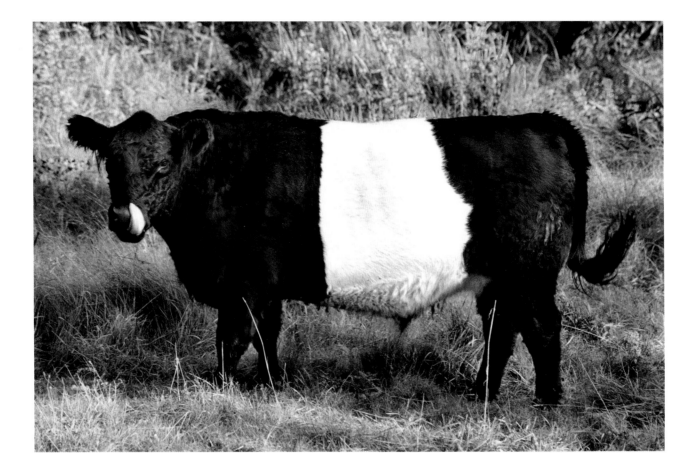

Belted Galloway Bull *Manchester, Vermont 1994*

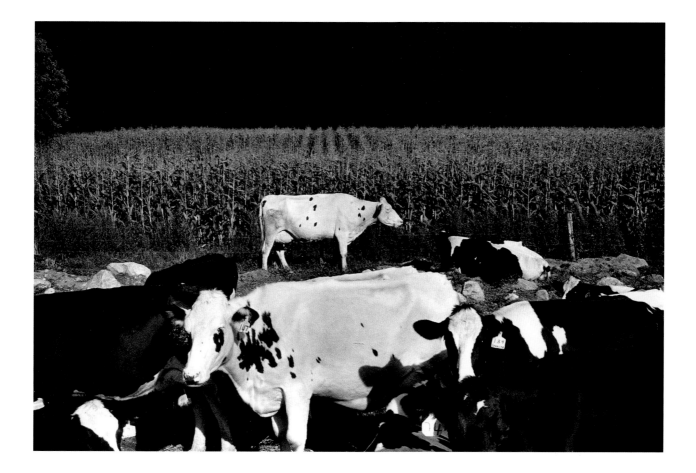

Holstein Cows *Dorset, Vermont 1988*

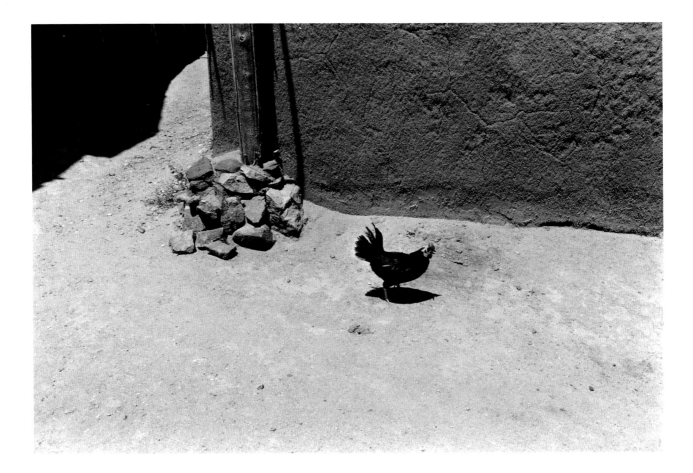

Bantam Chicken *Santa Fe, New Mexico 1994*

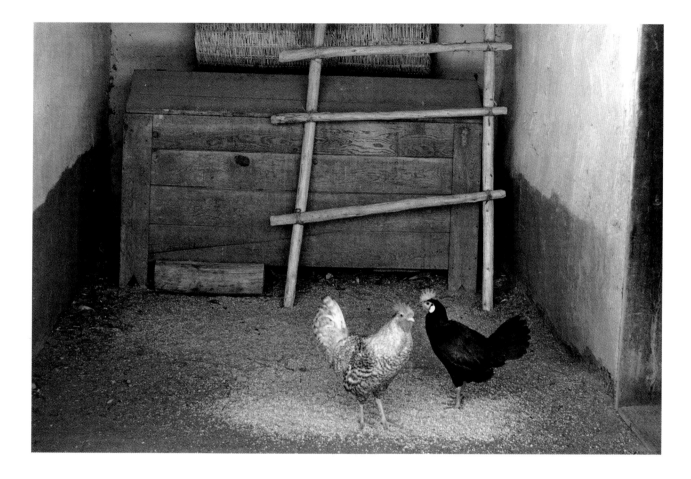

Bantam Chickens *Santa Fe, New Mexico* *1994*

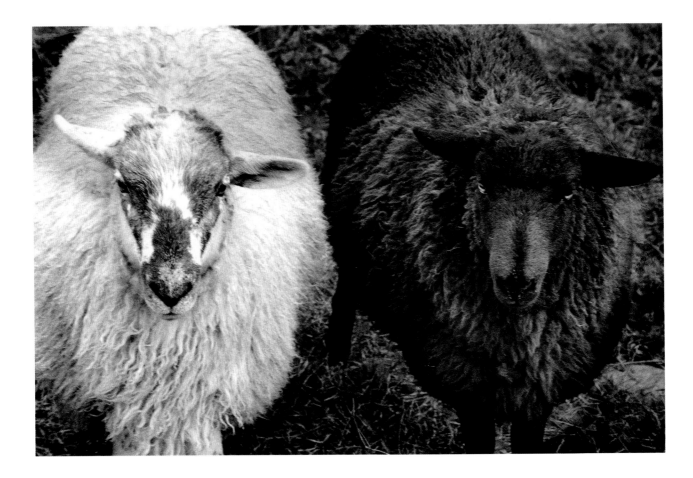

Sheep *Manchester, Vermont 1994*

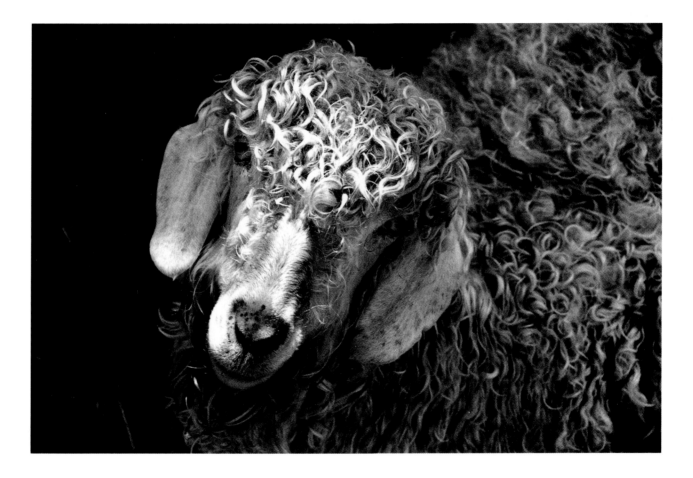

Angora Goat *Westminster West, Vermont* *1993*

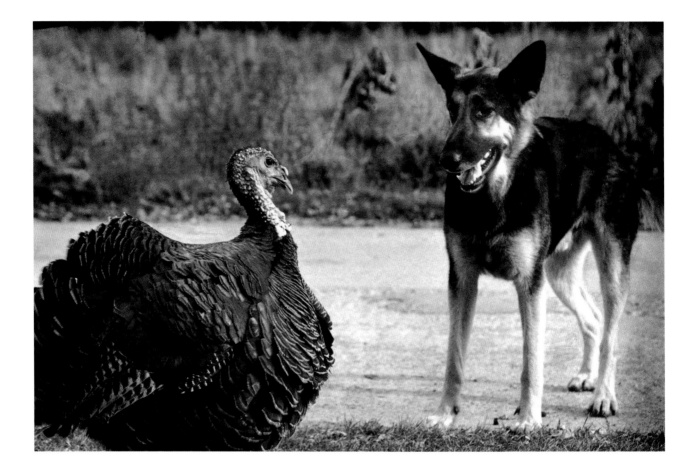

Bronze Turkey and German Shepherd *Manchester, Vermont 1994*

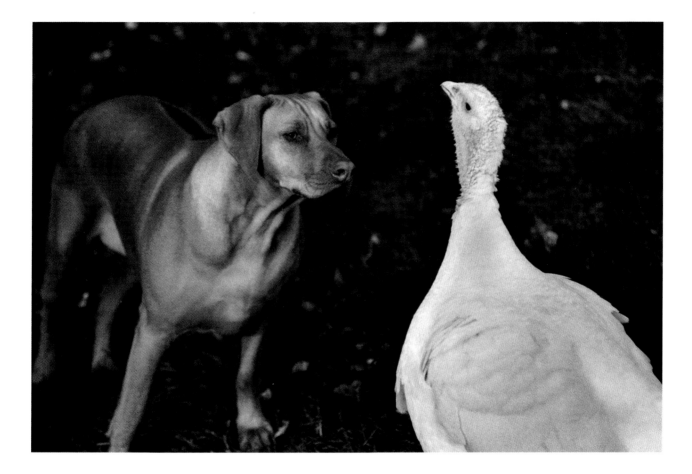

Rhodesian Ridgeback and White Turkey *Manchester, Vermont 1994*

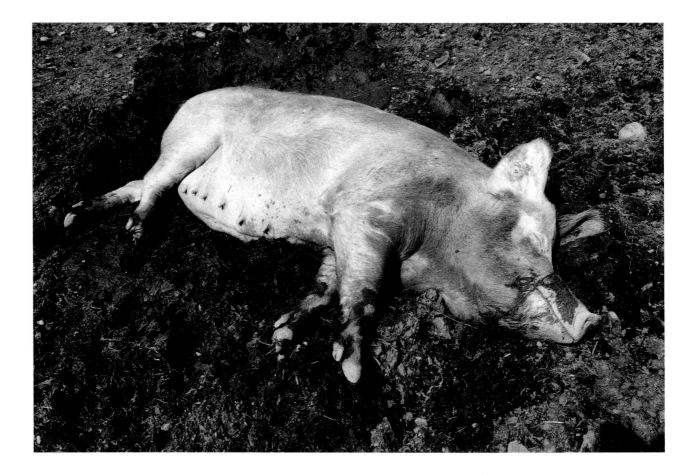

Yorkshire Cross Sow *Burlington Flats, New York* *1994*

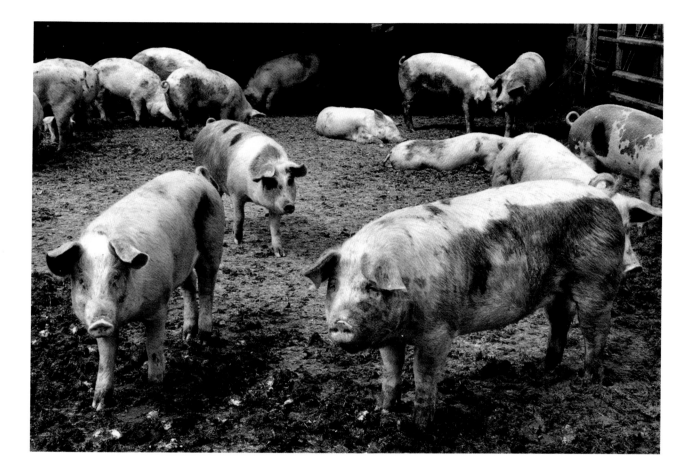

Yorkshire Cross Pigs *Burlington Flats, New York* *1994*

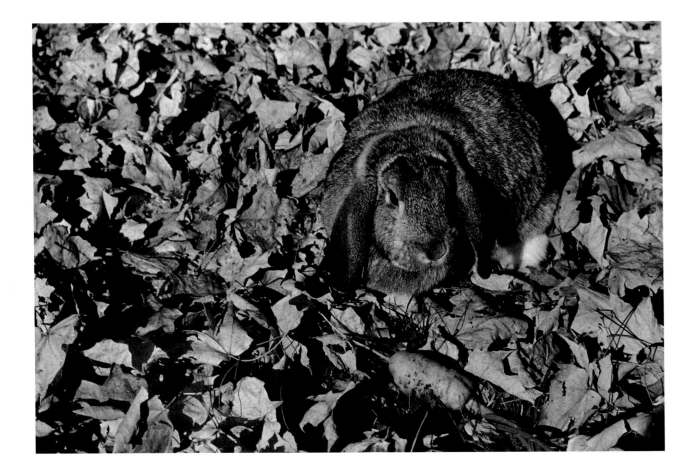

Lop-eared Rabbit *Montague, New Jersey 1992*

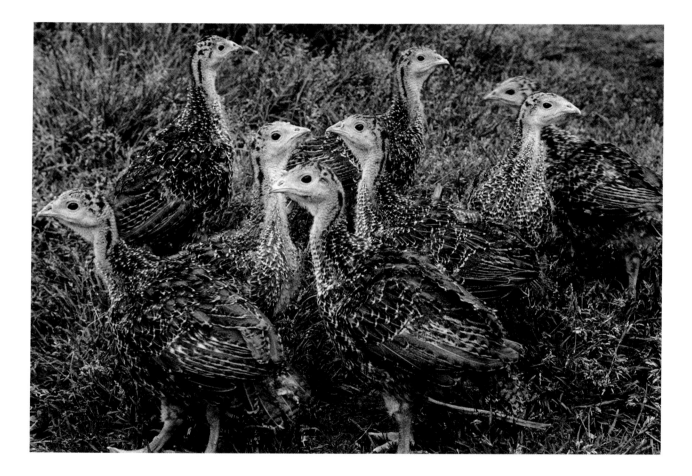

Bronze Turkey Poults *Westminster West, Vermont 1994*

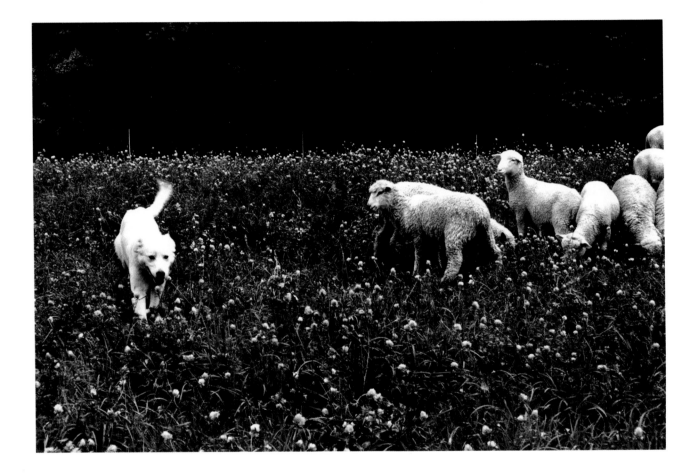

Maremma Guard Dog and Dorset Cross Sheep *Westminster West, Vermont 1993*

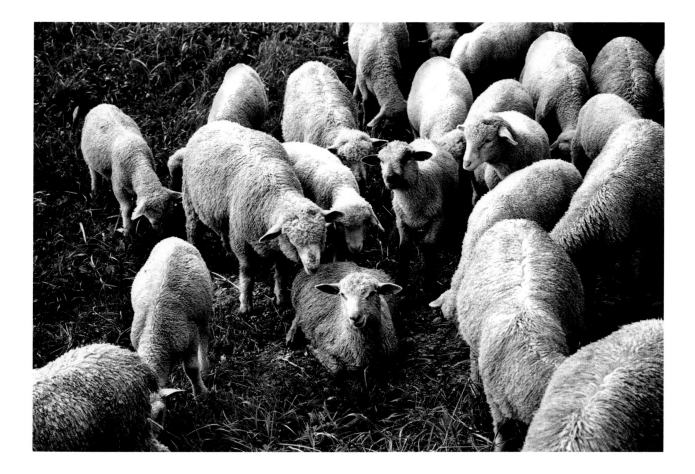

Dorset Cross Sheep *Westminster West, Vermont 1993*

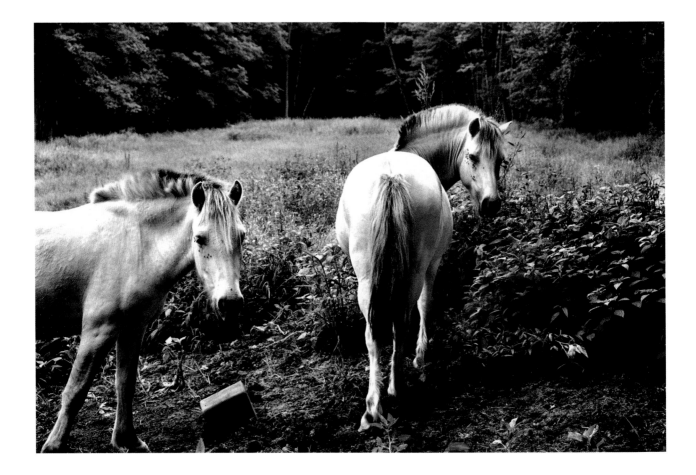

Norwegian Fjord Horses *Westminster West, Vermont 1993*

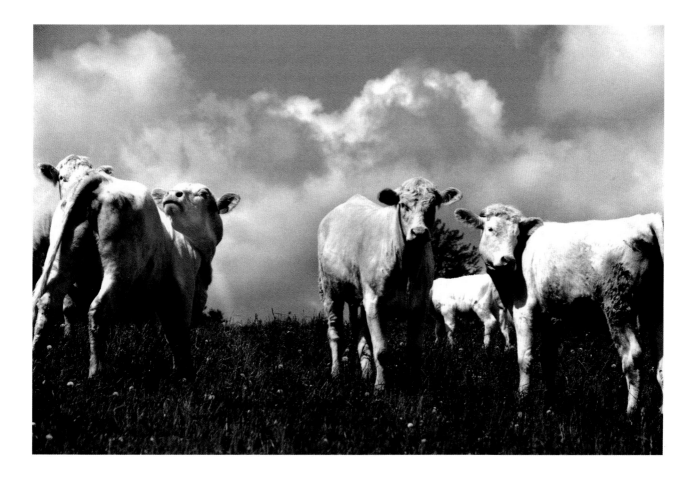

Charolais Cattle *Walton, New York 1993*

THIS BOOK IS DEDICATED TO MY BROTHER, PHILLIP

Acknowledgments

I would like to thank the following people for their time and support: Judith Braun, Matthew Carter, Melissa Davis, Nancy Drosd, Dakota Durkee-Heim, Marcia and Gino Garlanda, Lana Jokel, Maureen Kerwin, Ben La Farge, China Machado, Cynthia O'Neal, Daniel Okrent, Cybele Raver, Tina Raver, Peter Richmond, Riccardo Rosa, Kathy Ryan, Jerry Schatzberg, Charles Schwartz, Ina Shoenberg, Jane Trichter, Paul Wheeler, and Jack Youngerman.

I would also like to express my gratitude to those who made their farms and animals accessible to me: Battenkill Farm, Ralph Brill (White Column Farm), Frank Bruce, Robert Burton, Sharon Bushee (Bushee Farm), Chris and John Gambino (Hogs Hollow Farm), Dupuy-Spencer Farm, El Rancho de las Golondrinas, Estouville Farm, Evergreen Farm, Foster Farm, Irving Fraleigh, Pat and Bob Haas, Sven and Mariak Huseby, Sal Iacono (Iacono Farm), Kominski Farm, Andrew Littauer, Art and Stacy Ludlow, Harry and Barbara Ludlow, David and Cindy Major (Major Farm), Merck Forest and Farmland Center, Fred and Lynn Merusi (Seven Cedars Farm), Phil Quartier, Westminster Animal Hospital, and Ann Wilcox (Wilcox Dairy Farm).

Many thanks also to Leslie Stoker, Jim Wageman, Sarah Scheffel, and Vivian Polak for helping to make this book a reality.

And special love to my mother, Chelly, and my daughter, Sabrina.

Designed by Jim Wageman

Typefaces in this book are Celestia Antiqua, designed by Mark van Bronkhorst,
and Contrivance, designed by Frank Heine

Printed and bound by Arnoldo Mondadori Editore, S.P.A.,
Verona, Italy